Wisdom With Understanding is Better Than Rubies

Lurine Karrow Greenberg Fine Arts Collection

Hats Off
photographs by
Jason Bell

Edited by Guy Harrington

DEWI LEWIS
PUBLISHING

First published in the UK in 2002 by
Dewi Lewis Publishing
8 Broomfield Road, Heaton Moor
Stockport SK4 4ND, England

www.dewilewispublishing.com
www.jasonbellphoto.com

ISBN: 1-899235-49-3

Editor: Guy Harrington
Photo Retouching: Stephen Langmanis
Design & Artwork Production: Dewi Lewis Publishing
Print: EBS, Verona

Acknowledgements

My thanks first and foremost to Guy Harrington for having the idea for this project and then making it happen. I also could not have done it without the following: my agents, Soho Management, and especially Fiona Rooke-Ley; Elizabeth Gale and Angela Fletcher at **mentality** for their unstinting support and for the original Hats Off concept; my assistant, Lindsey Hopkinson; Kate Winslet for agreeing very early on to take part and help get the ball rolling; Emma Leslie; Public Eye and especially Ciara Parkes; The Outside Organisation and especially Caroline McAteer; Anna Raynsford; Cynthia Lawrence-John; Alex Price; Anthony Maule; Jochen Fuchs; Kate Lee; Robin Turner; Katz Pictures and especially Anthony and Matt; The Lab Soho.

The cult of celebrity is greater than ever – our fascination with it boundless. It is hardly surprising therefore that many charities seek celebrity endorsement to help raise their profile and generate interest. The challenge though is to do something both positive and different, to harness that interest for a useful purpose in an original way.

mentality is a new UK charity and the only one dedicated solely to the promotion of mental health. One of the things that struck me when I met with **mentality** was their statement that the stigma of admission is often the major obstacle in dealing with mental health problems.

It seemed to me that involving celebrities in this context was particularly apposite. The individuals are photographed here not just because they care and have offered to help, but because their celebrity itself makes a point. What better way to highlight a secret than by focusing on those who are not allowed them.

One in four people experiences a mental health problem at some point in their life. This means that you almost certainly know someone who is or has been affected.

So Hats Off is about addressing that stigma of admission, resisting the urge to keep it under your hat and raising our hats to those that have successfully overcome their problems.

Jason Bell

The **mentality** team would like to thank Jason Bell and the entire team at Soho Management, led by Guy Harrington, for being so supportive of this initiative. Jason is donating all his profits from the sale of this book to **mentality** and that money will go directly to organisations run by and for people with mental health problems and we hope will help to change lives.

Myths and stereotypes about people with mental health problems are widespread in our society. Fears and misconceptions, fuelled by tabloid headlines, contribute centrally to the exclusion experienced by many people living with a diagnosis of mental illness.

Hats Off was created by **mentality**, a national charity dedicated to promoting mental health. Hats Off symbolises respect for people who have experienced mental health problems. To quite literally take our hats off to their achievements. People with mental health problems do not want sympathy, they want equality and recognition of their experiences. These issues concern us all, not least because any one of us could experience a mental health problem.

We have been overwhelmed by the response to Hats Off and by the commitment of so many people to challenging one of the last taboos. We are grateful to all those involved in Hats Off, those who designed or donated hats, were photographed, were interviewed or who gave their time. We would particularly like to thank the many people with mental health problems who contributed.

We are grateful for your support and take our hats off to you.

Elizabeth Gale
mentality
www.mentality.org.uk

Ewan McGregor

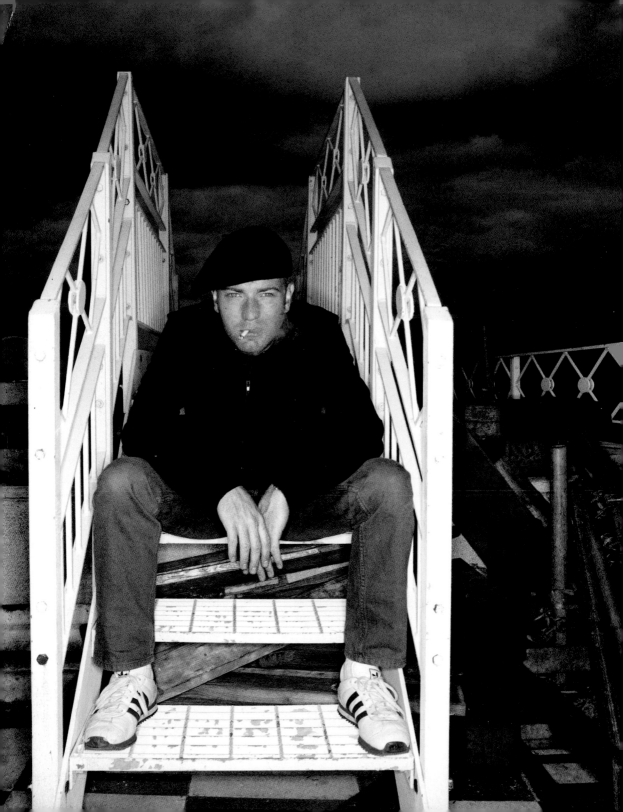

Travis

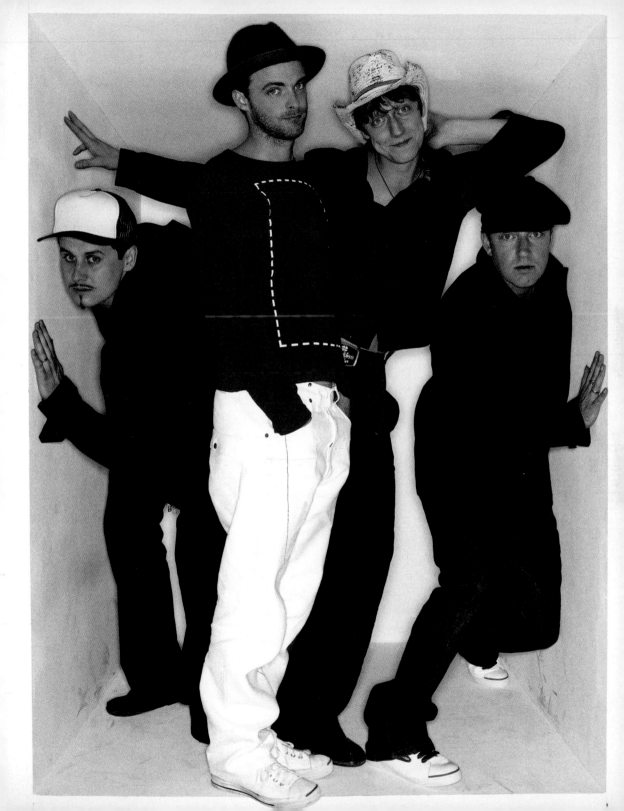

Glenda Jackson

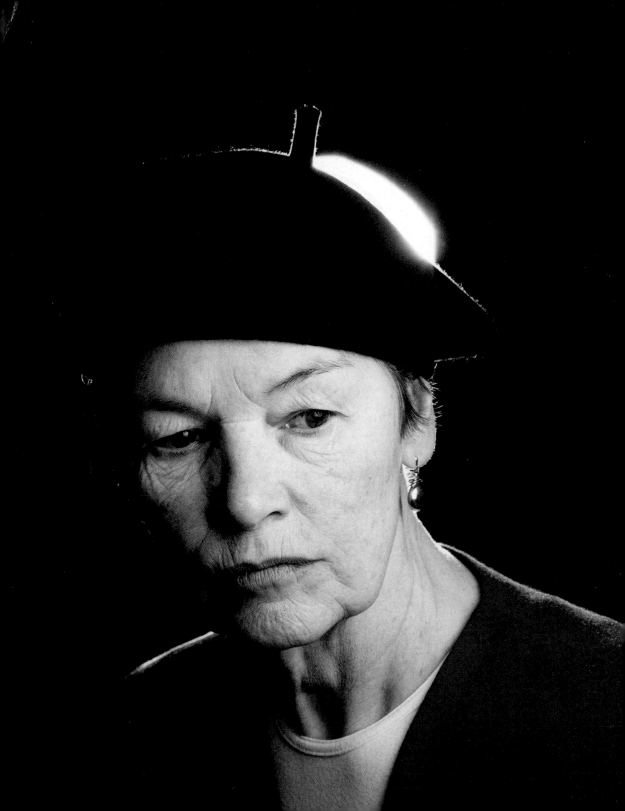

Emily Watson

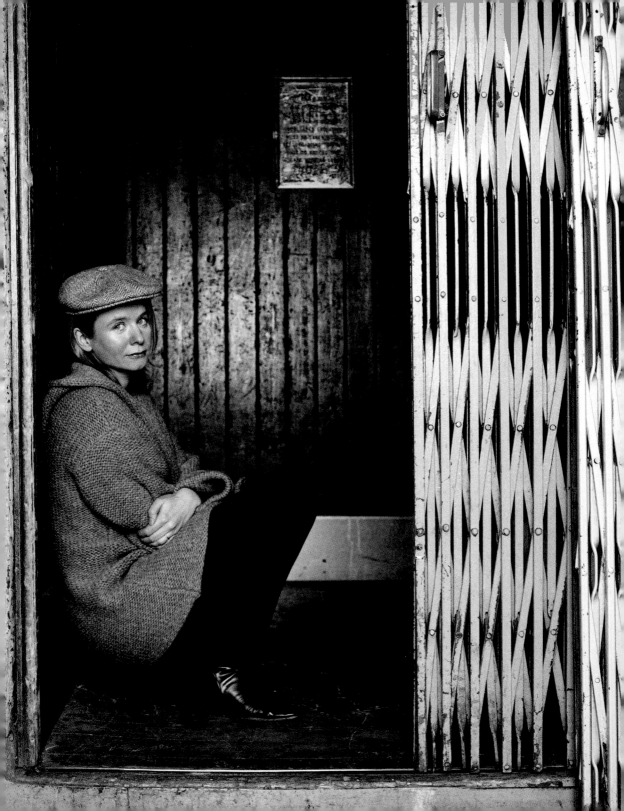

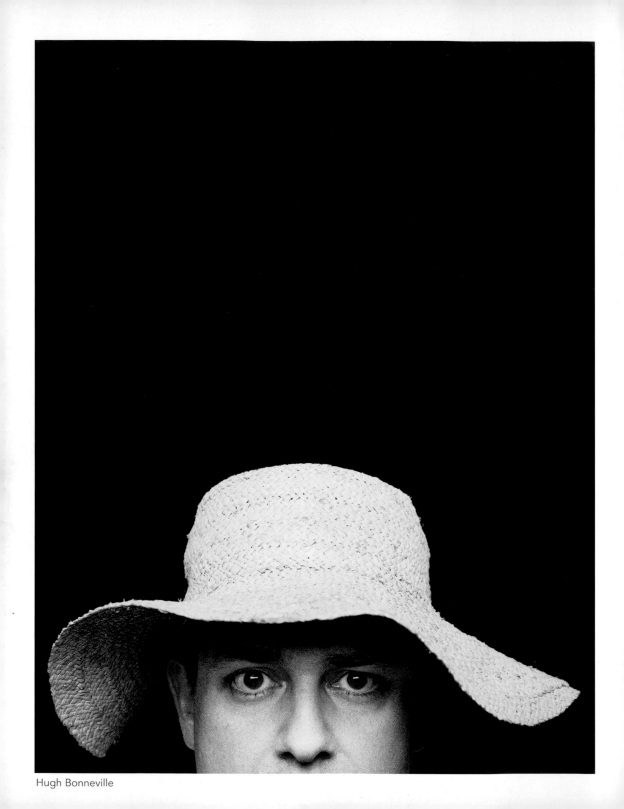

Hugh Bonneville

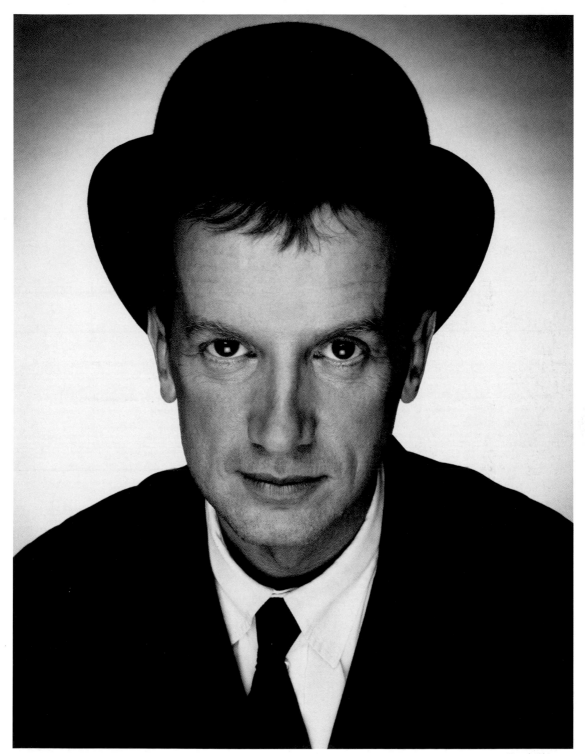

Frank Skinner

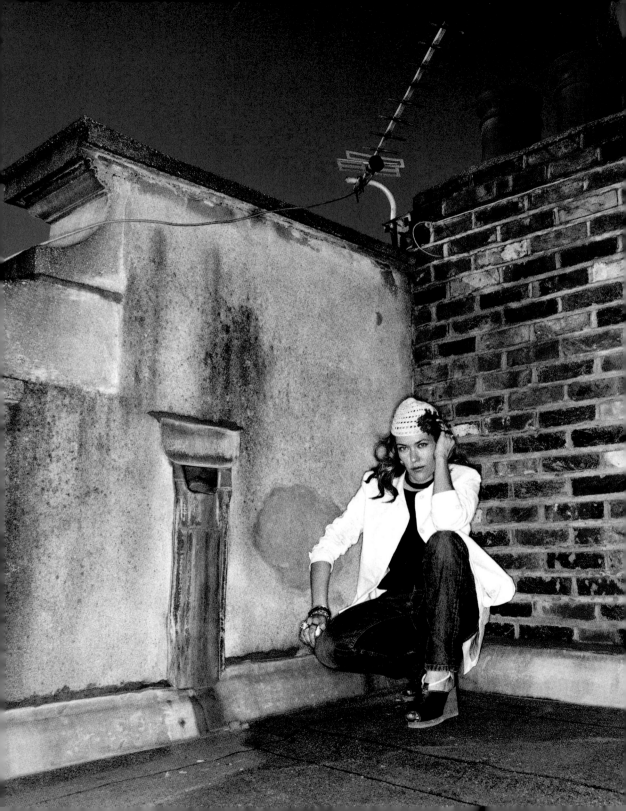

Cerys Matthews

Hugh Grant

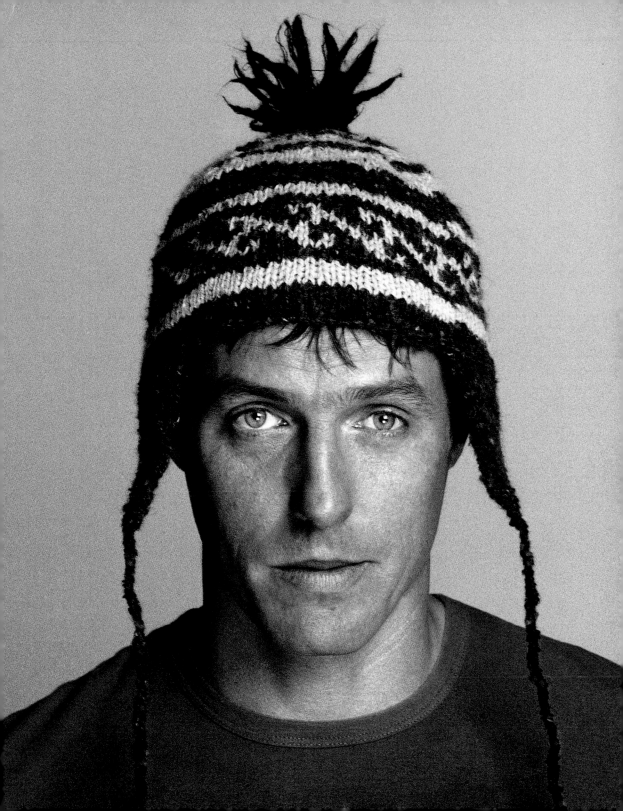

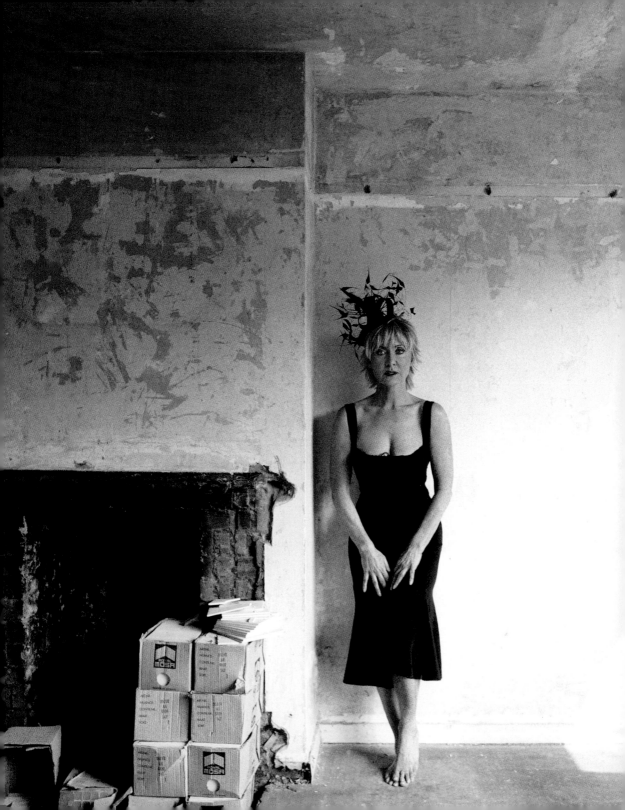

Lulu

Patrick Cox

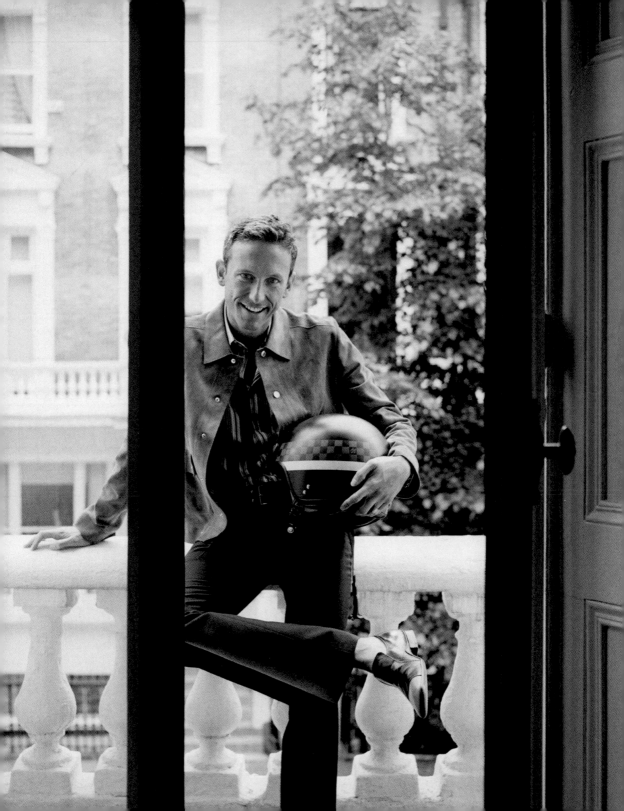

Elton John and David Furnish

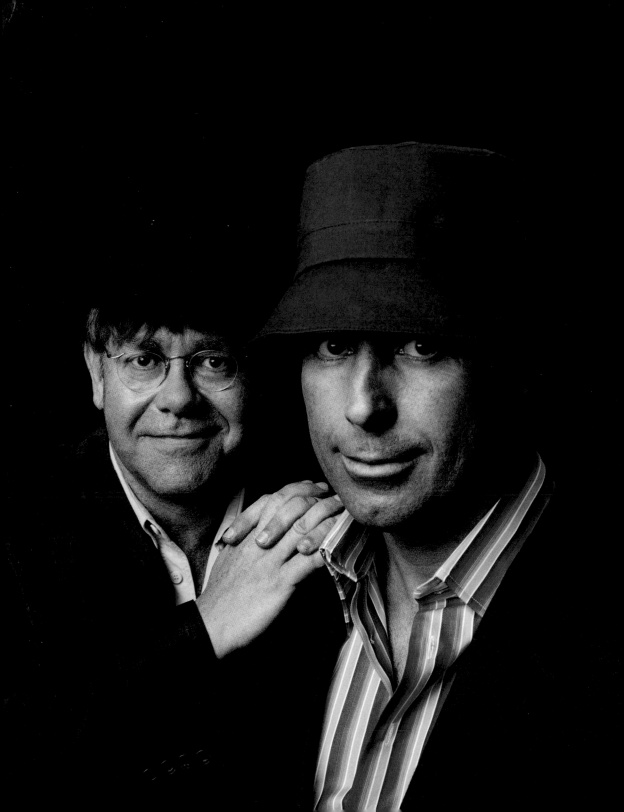

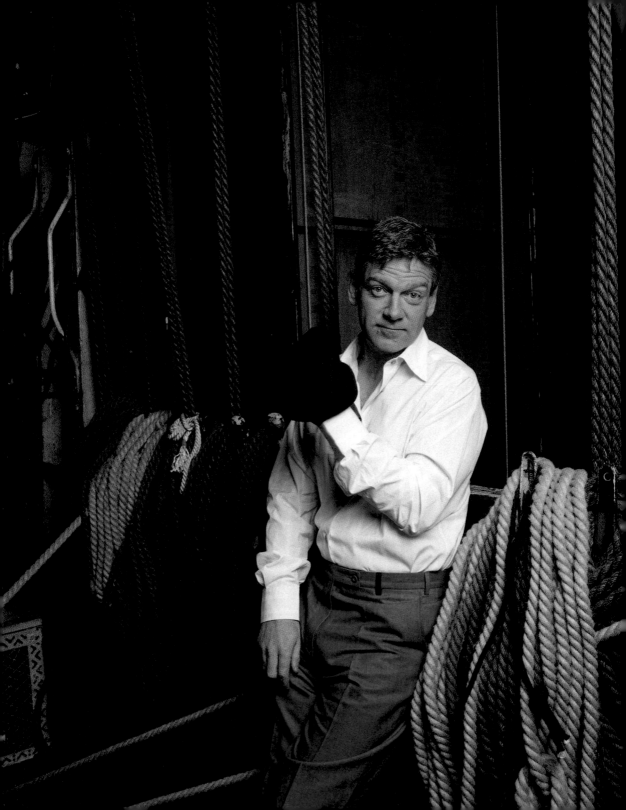

Kenneth Branagh

Meera Syal

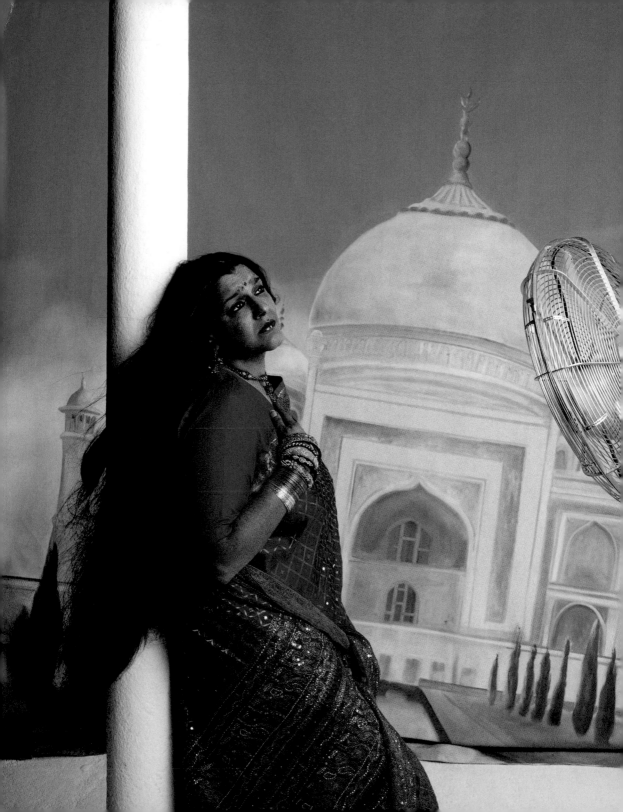

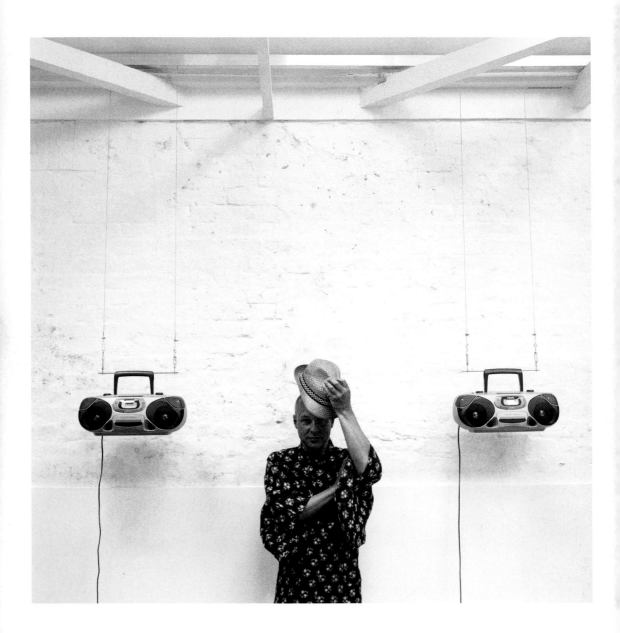

Brian Eno

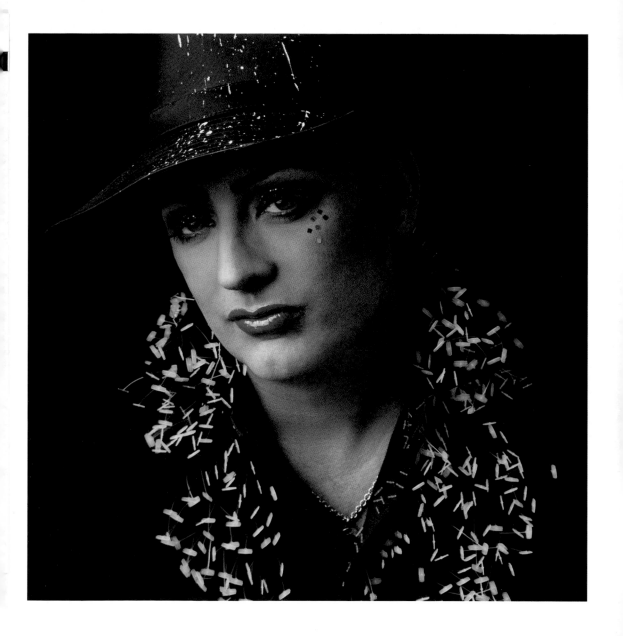

Boy George

Cherie Booth

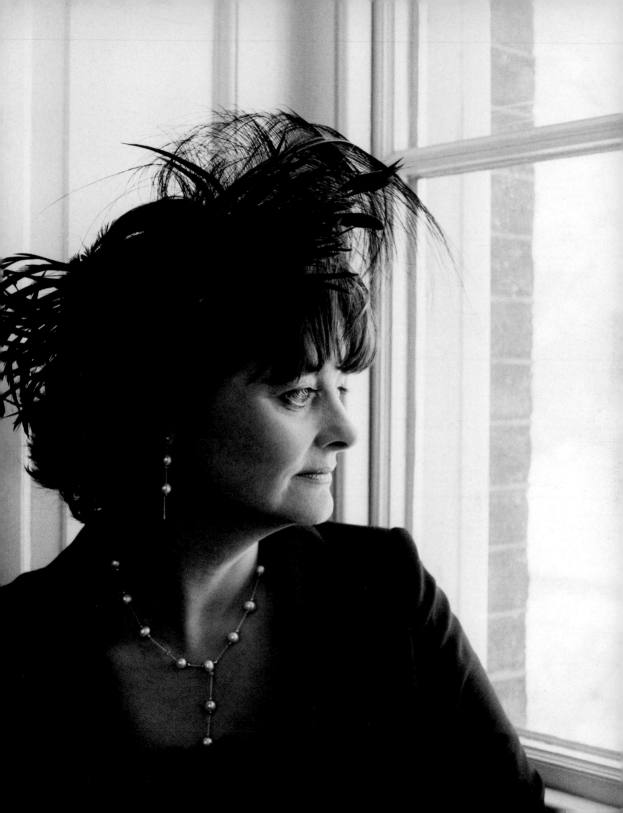

Macy Gray

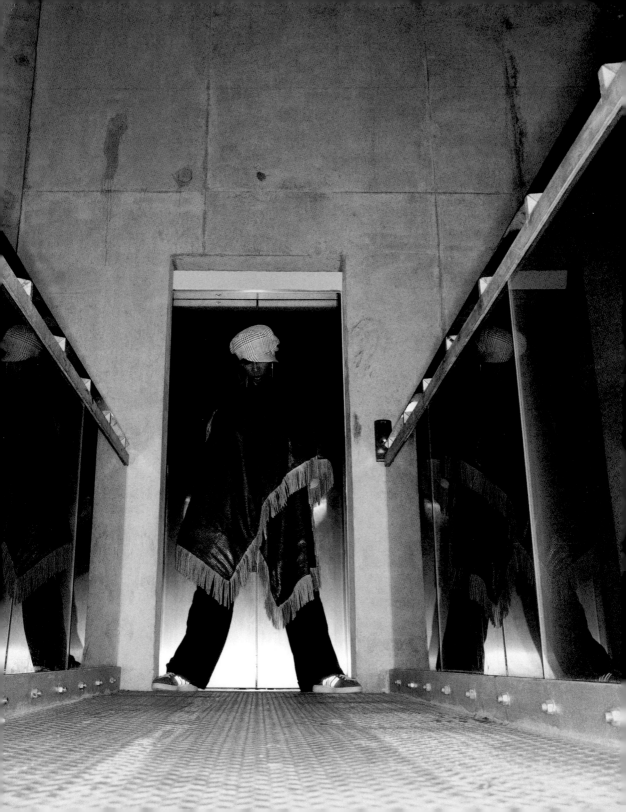

Gavin Turk

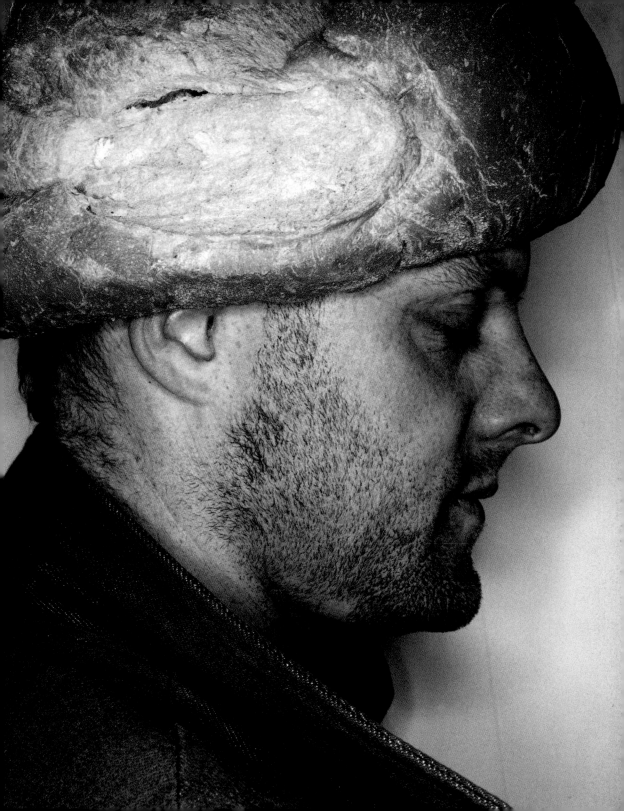

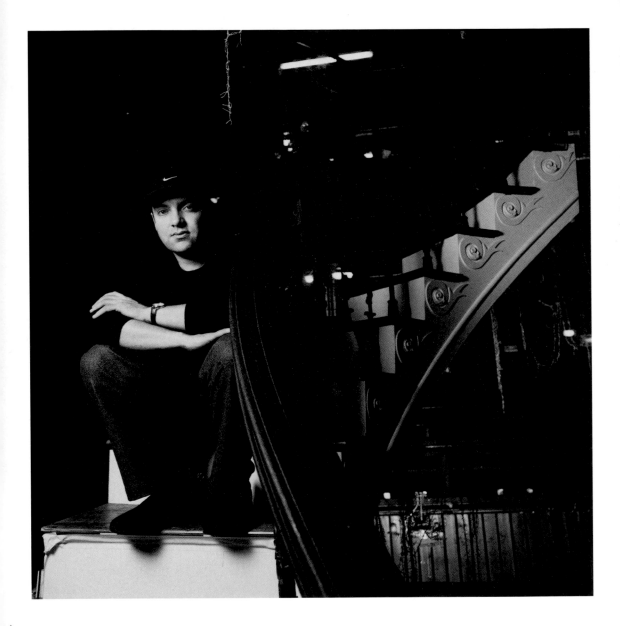

Sam Mendes

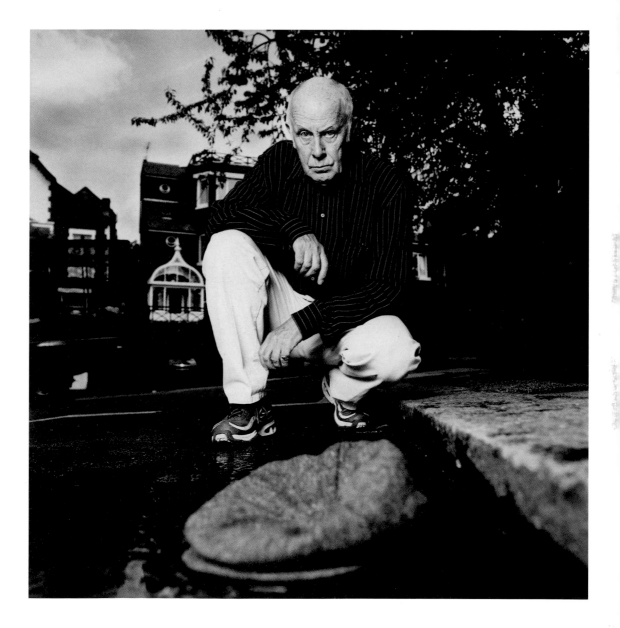

Richard Wilson

Judi Dench

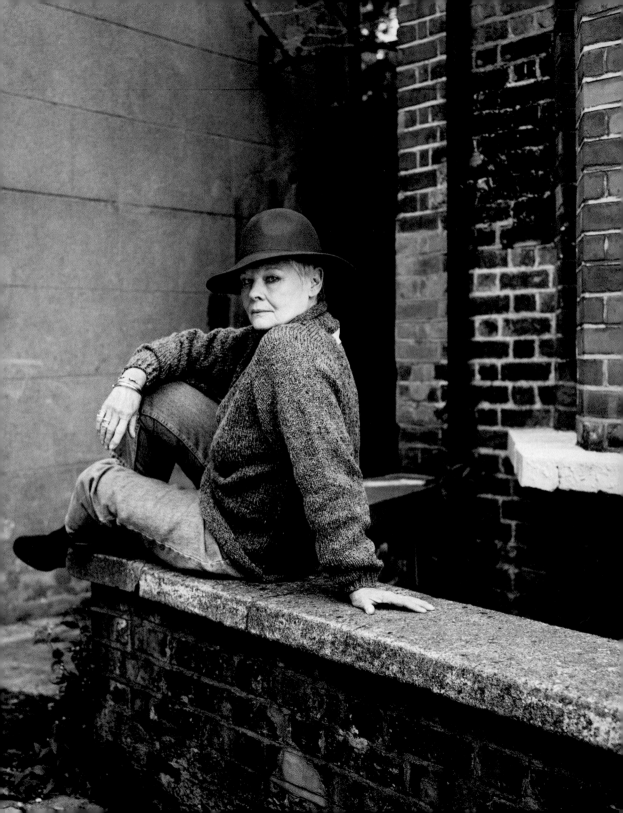

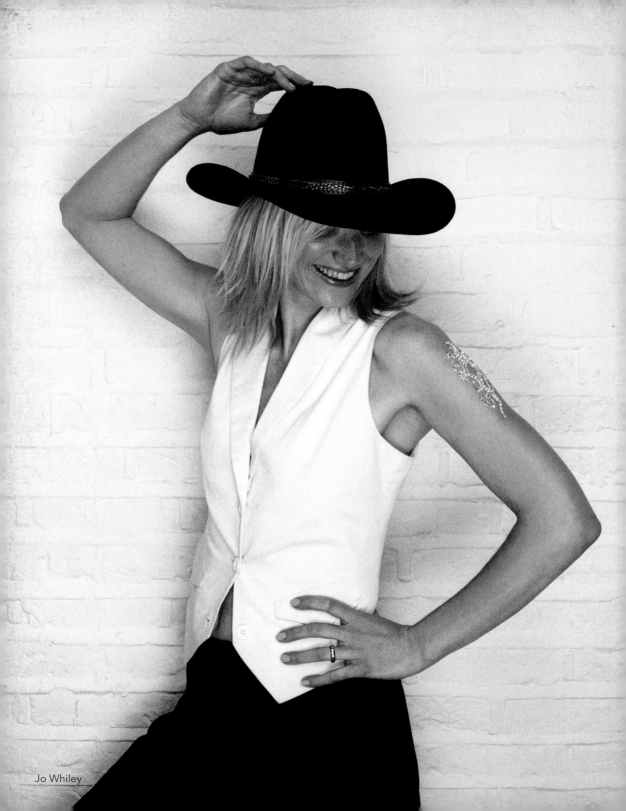

Jo Whiley

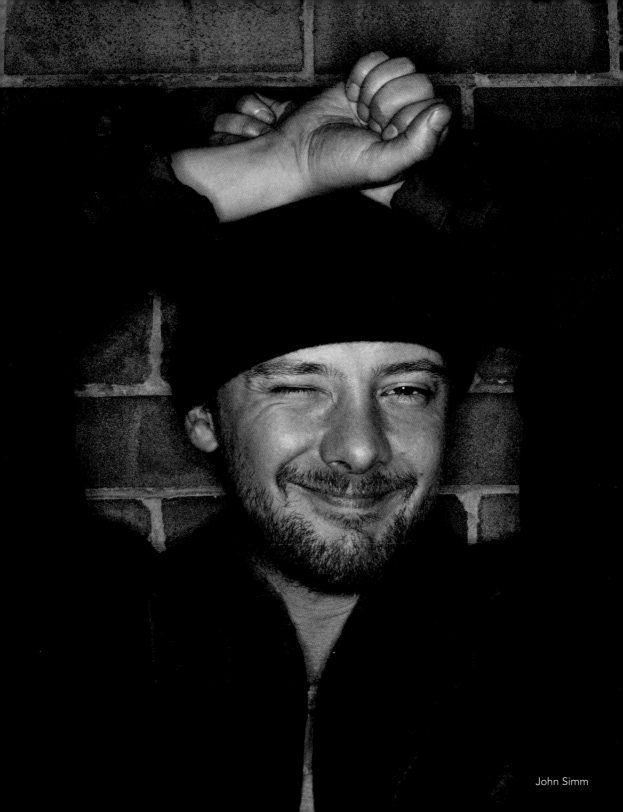

John Simm

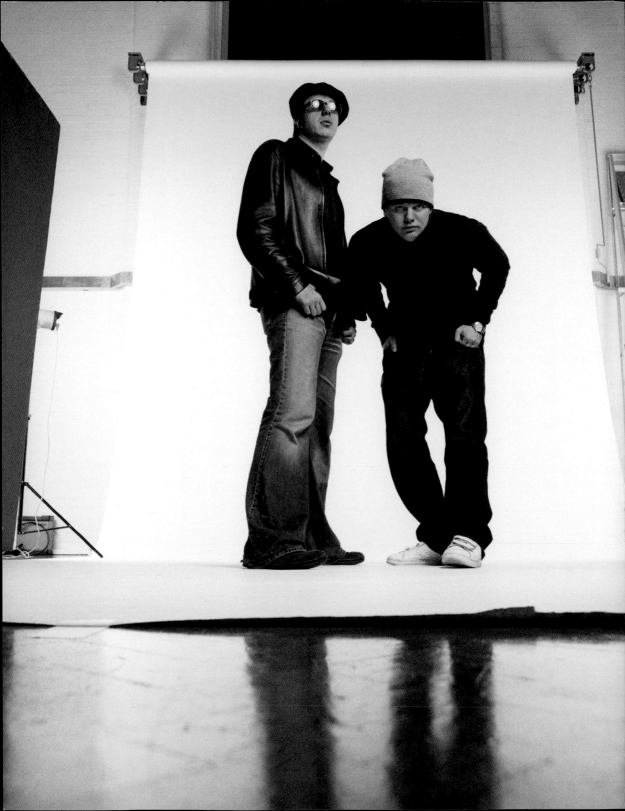

The Chemical Brothers

Terry Waite

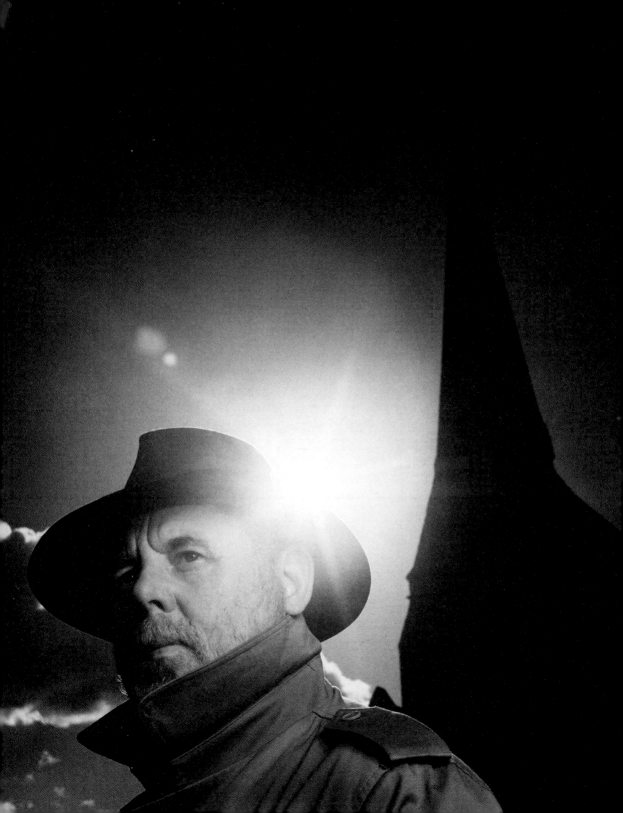

Kate Winslet

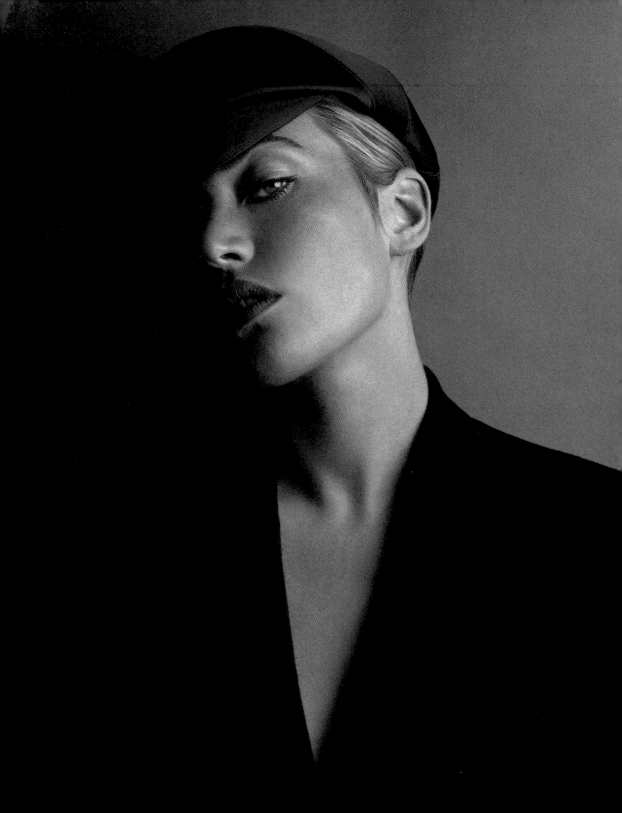

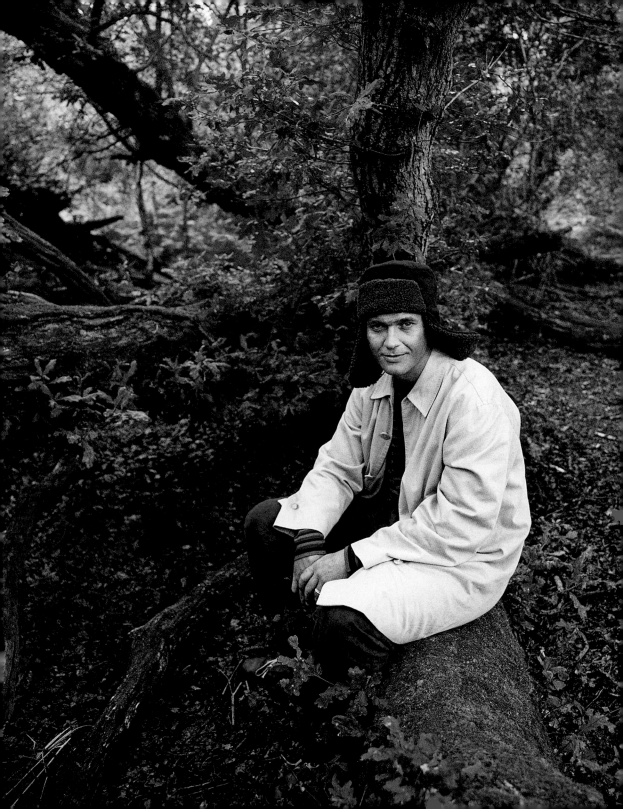

Dougray Scott

Paz Vega

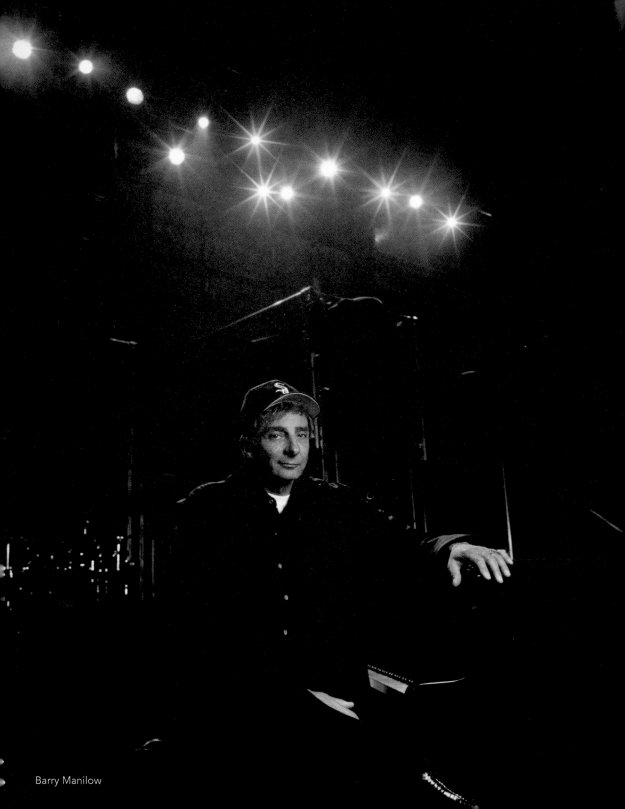

Barry Manilow

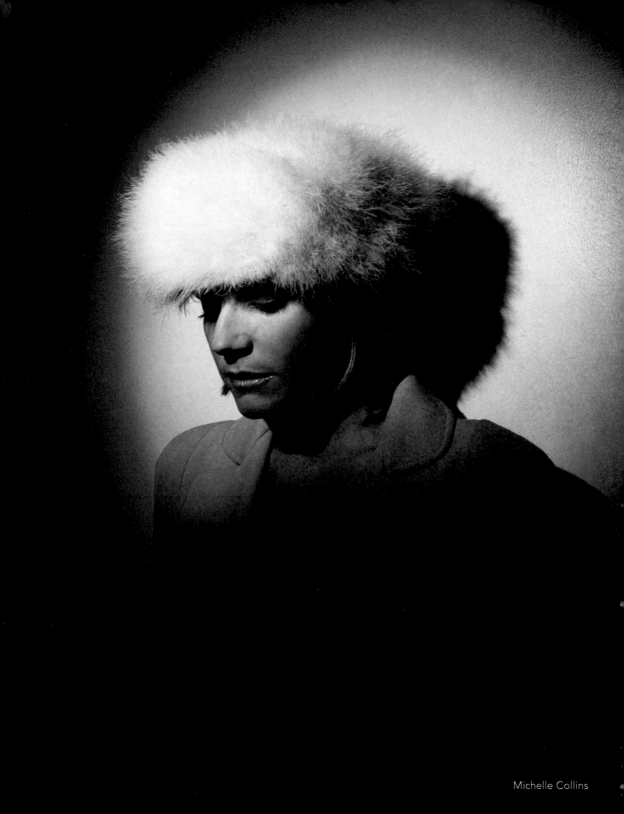

David Blaine

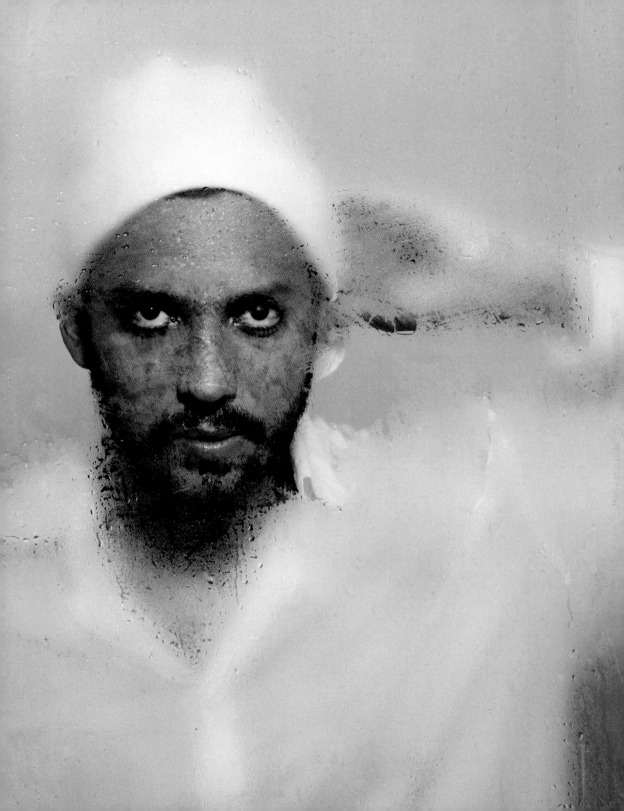

Charles Kennedy

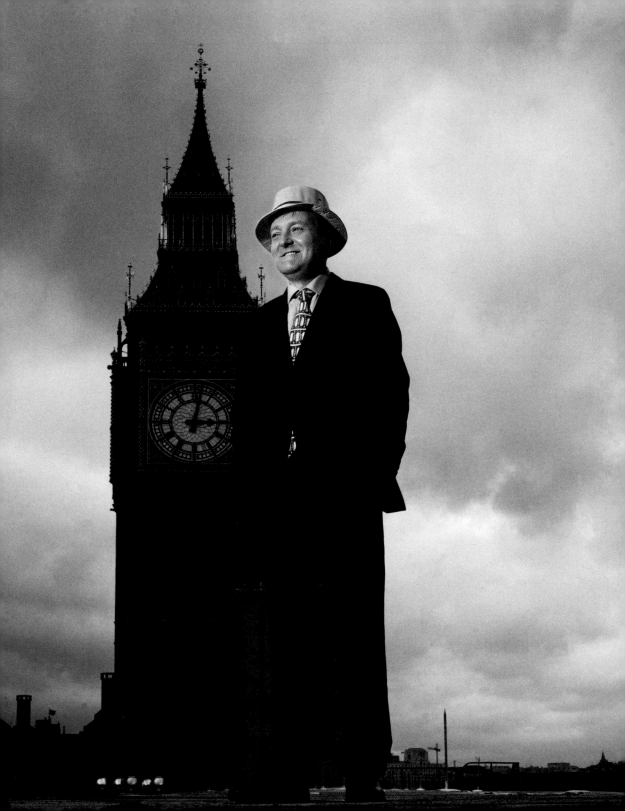

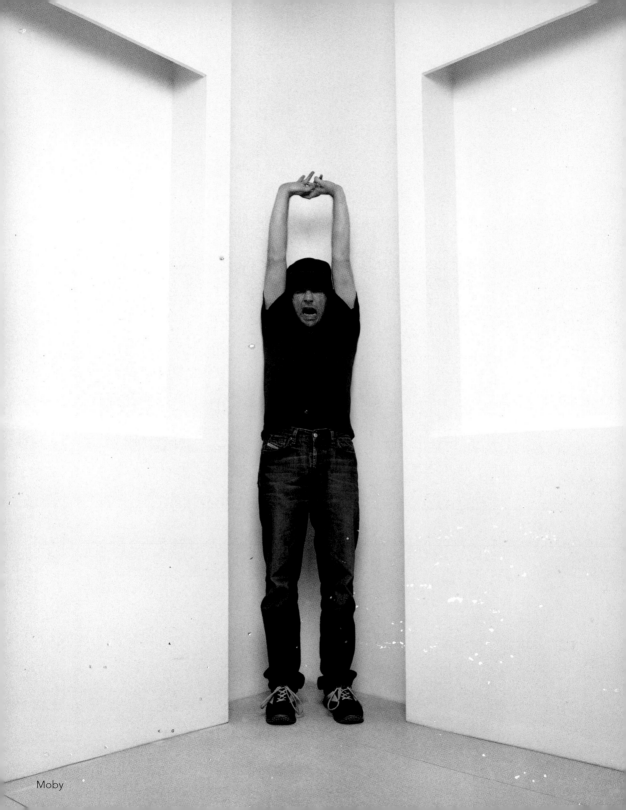

Moby

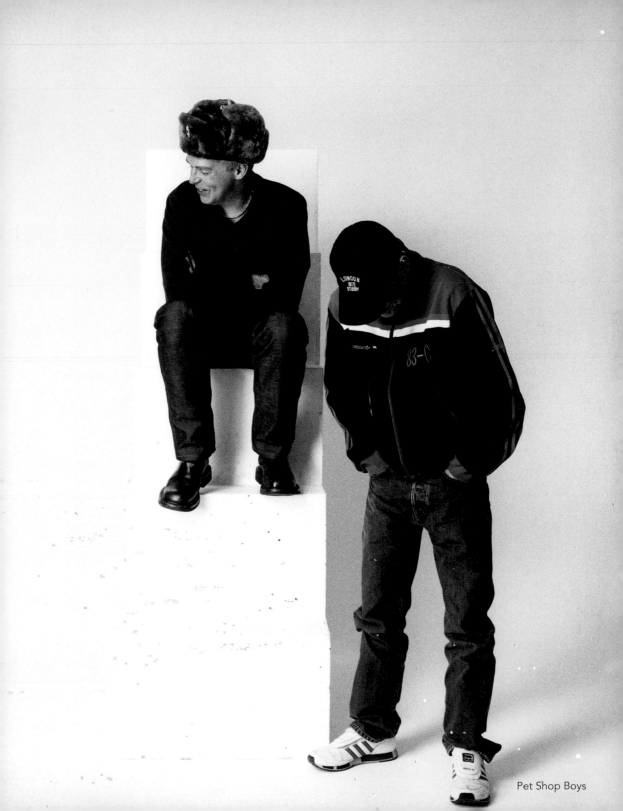

Pet Shop Boys

Victoria Beckham

Cybill Shepherd

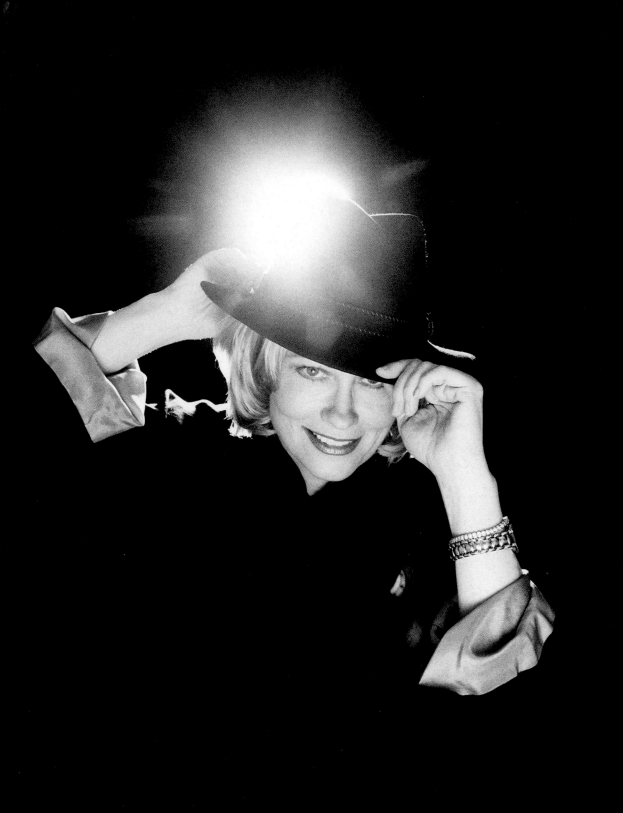

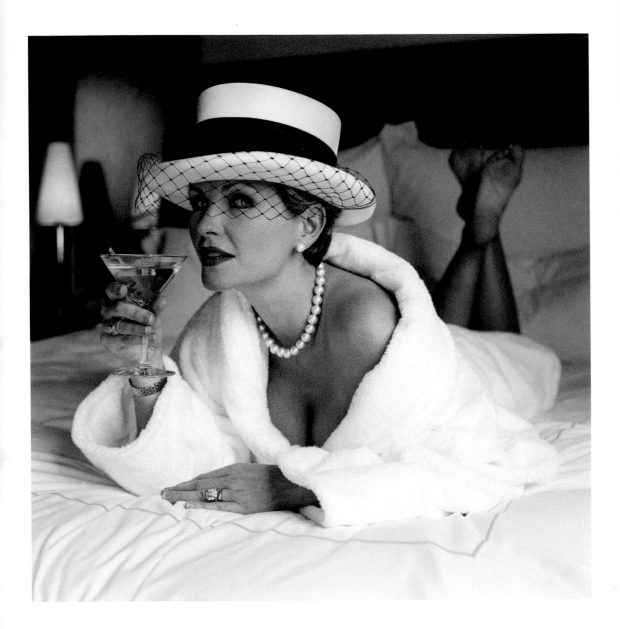

Fiona Fullerton

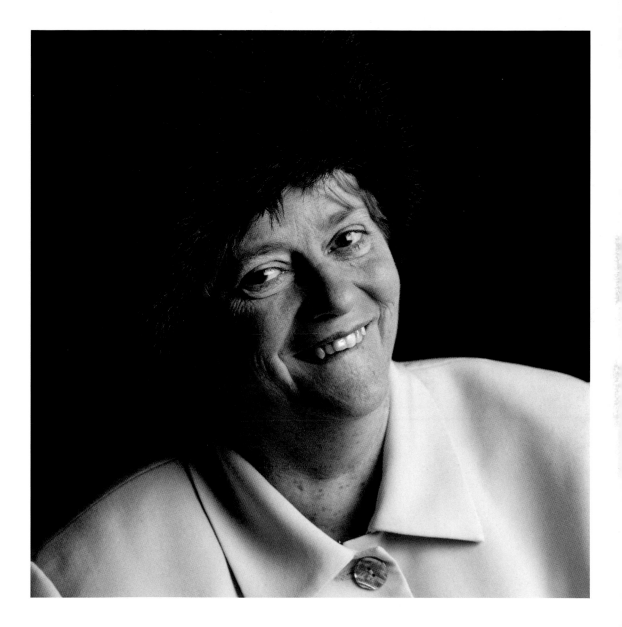

Ann Widdecombe

Dervla Kirwan

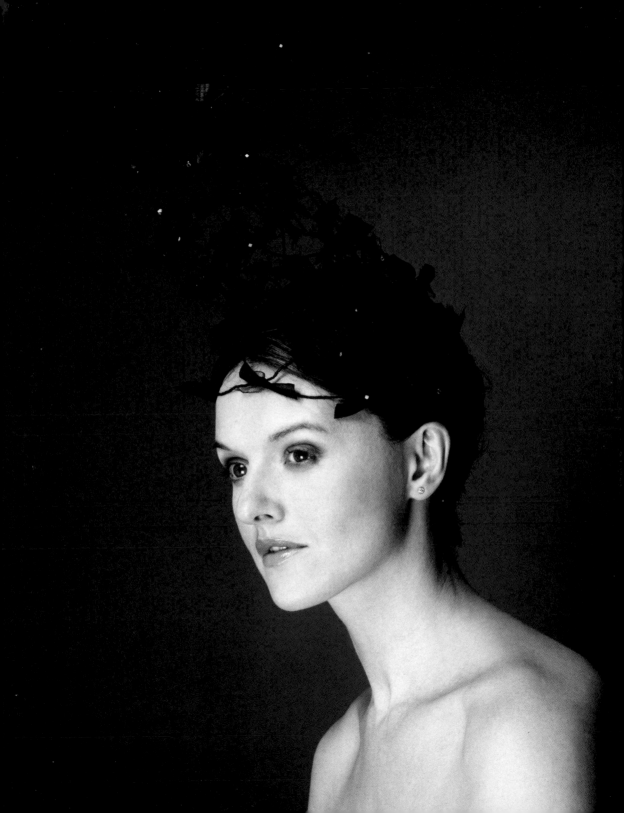

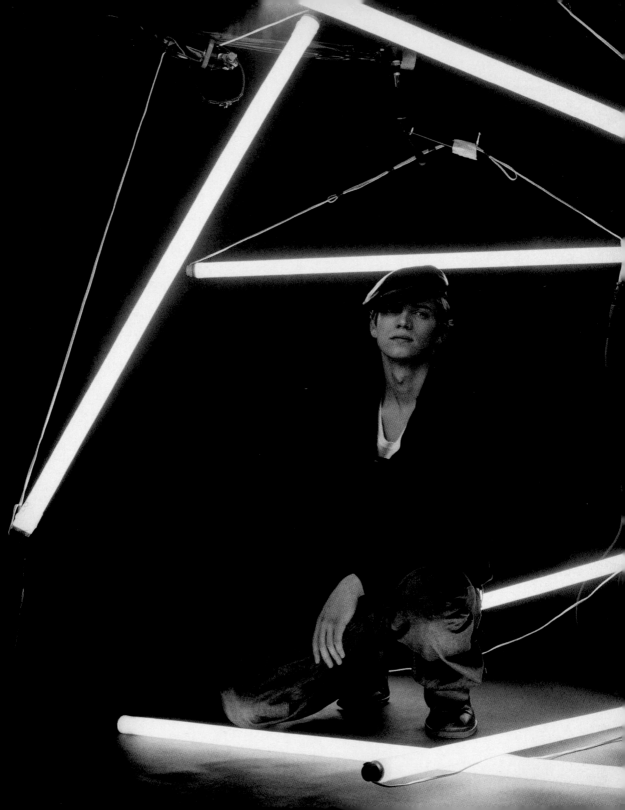

Hayden Christensen

Alicia Keys

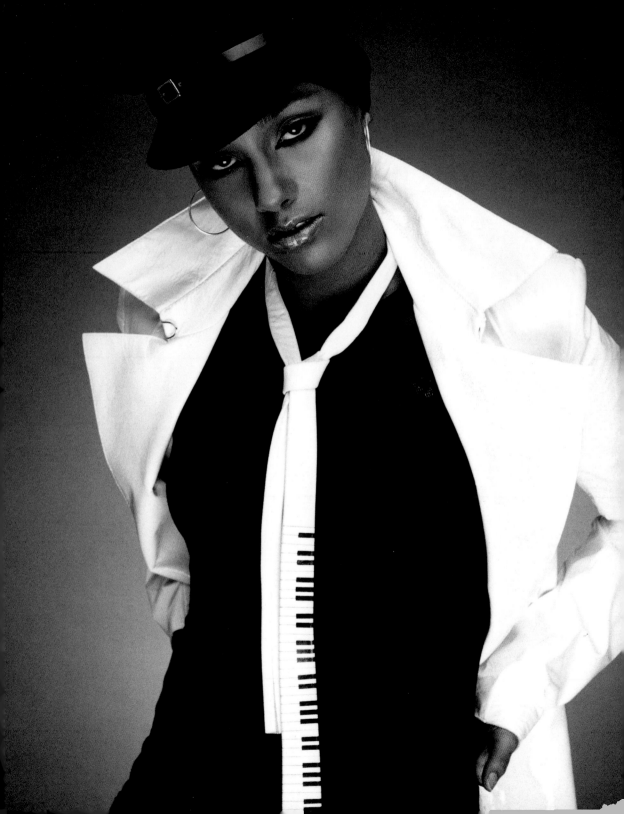

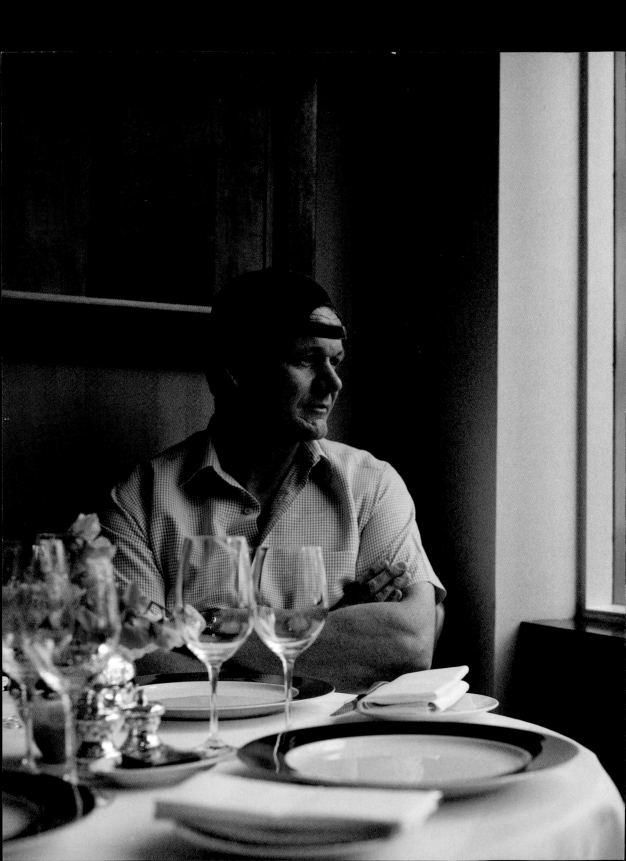

Gordon Ramsay

Dermot O'Leary

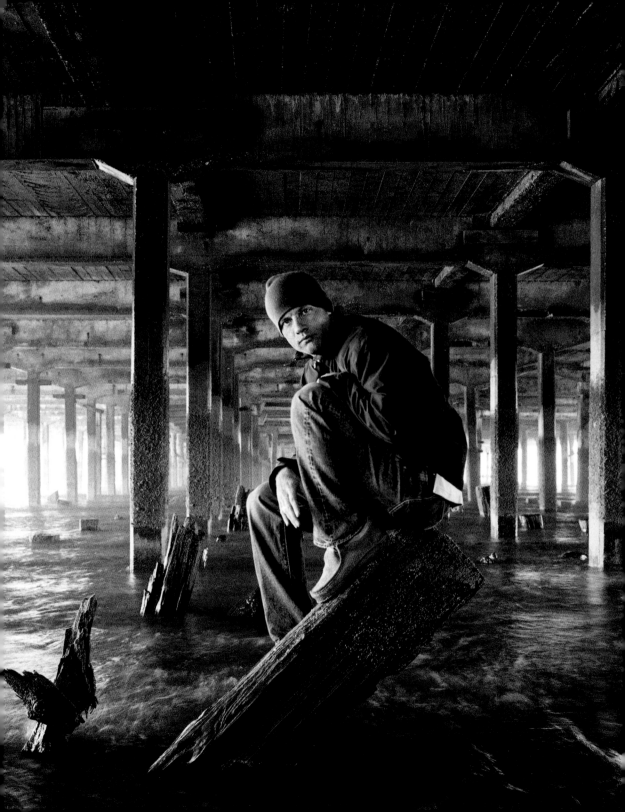

Trevor Nelson

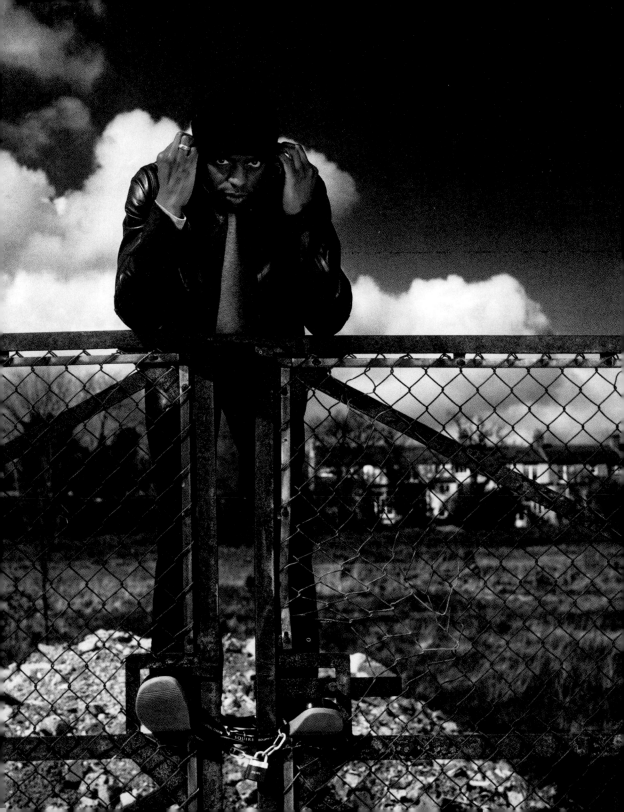

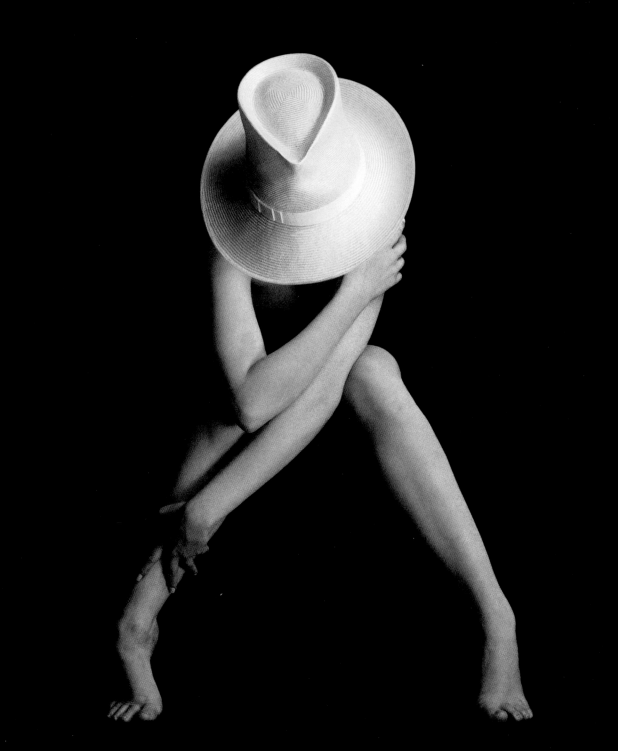

Sophie Ellis Bextor

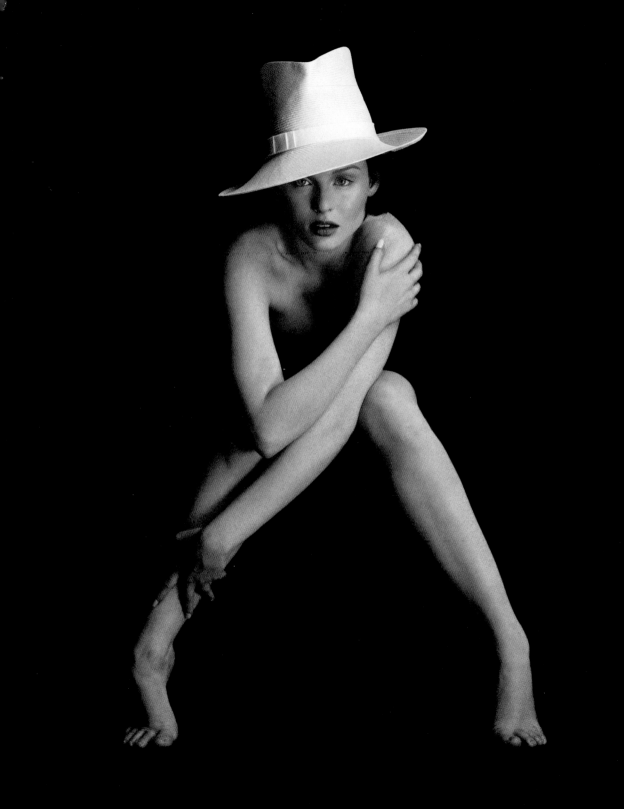

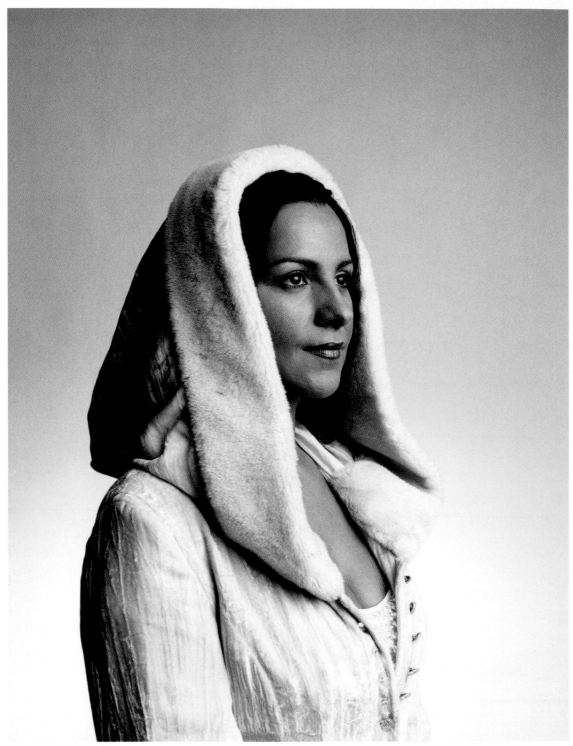

Angela Gheorghiu

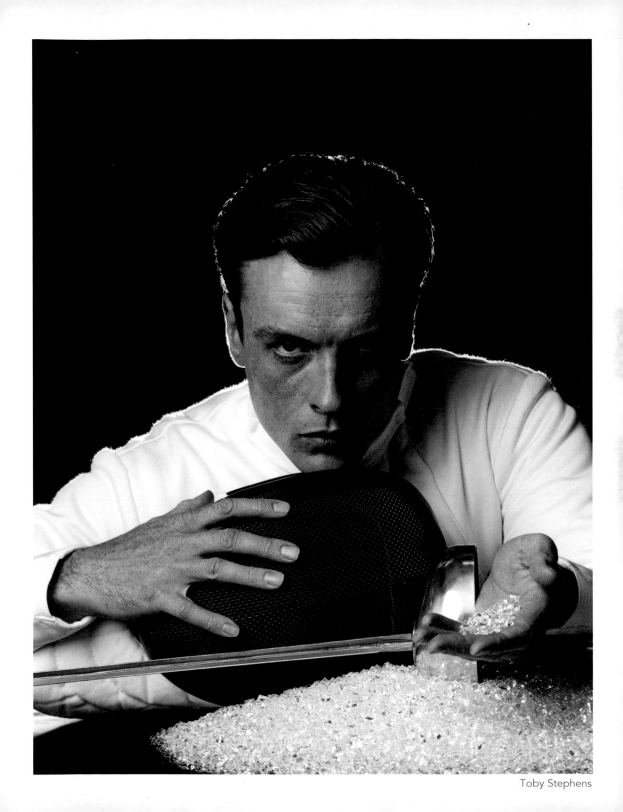

Toby Stephens

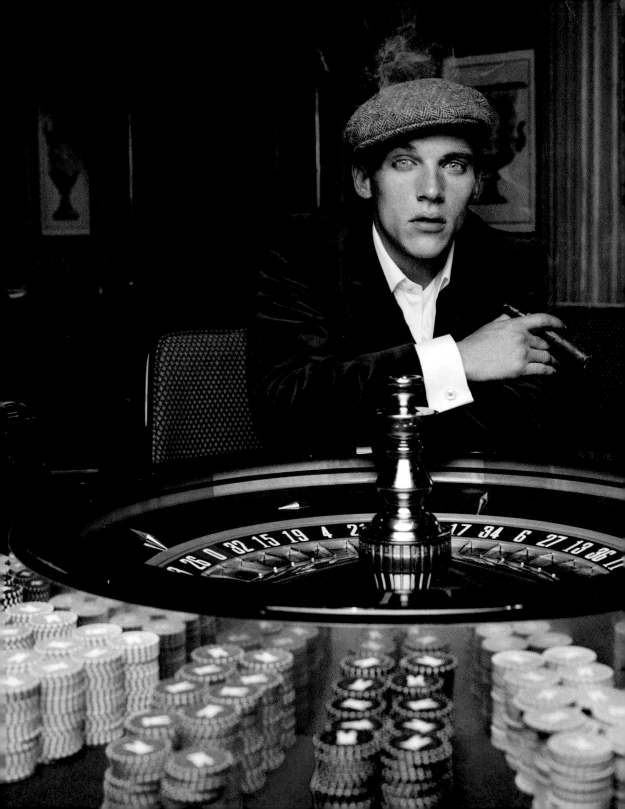

Jonathan Rhys Meyers

Robson Green

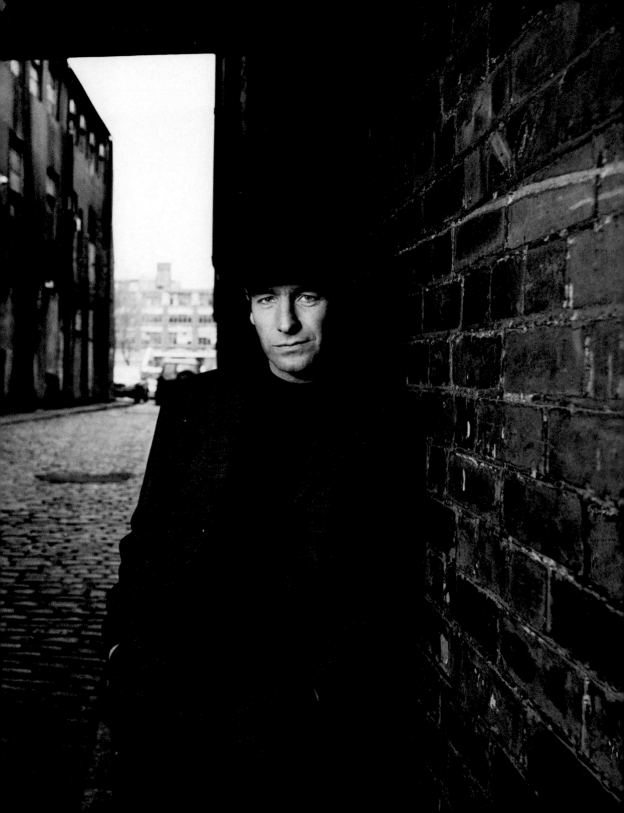

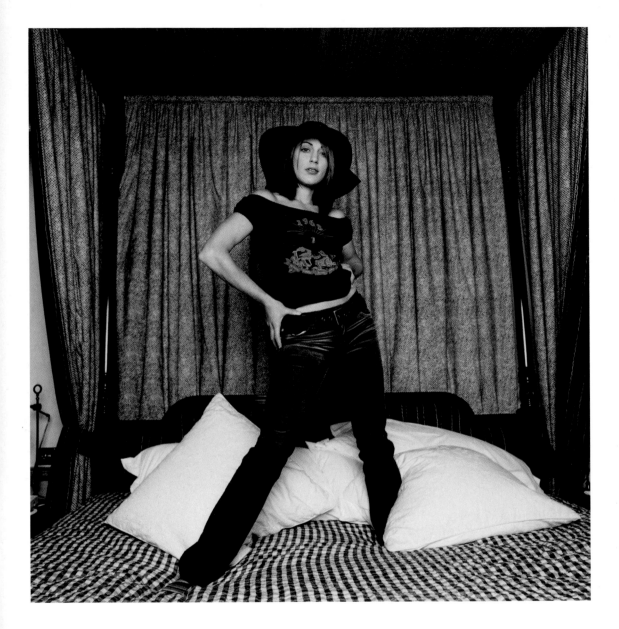

Summer Phoenix

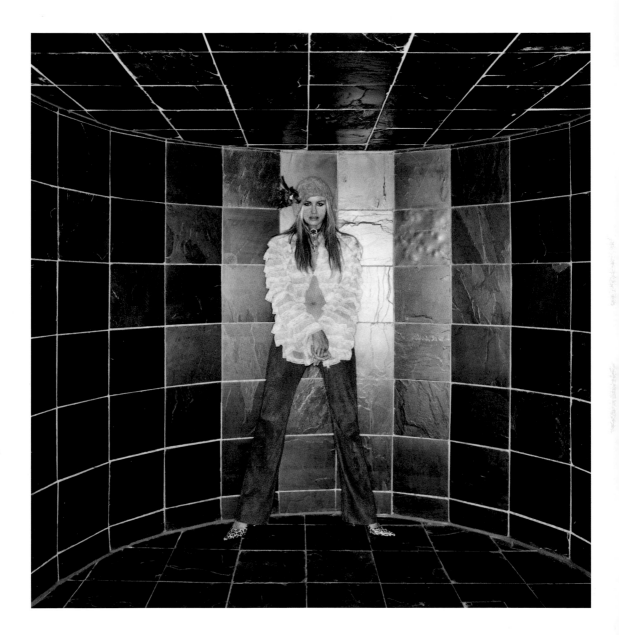

Daryl Hannah

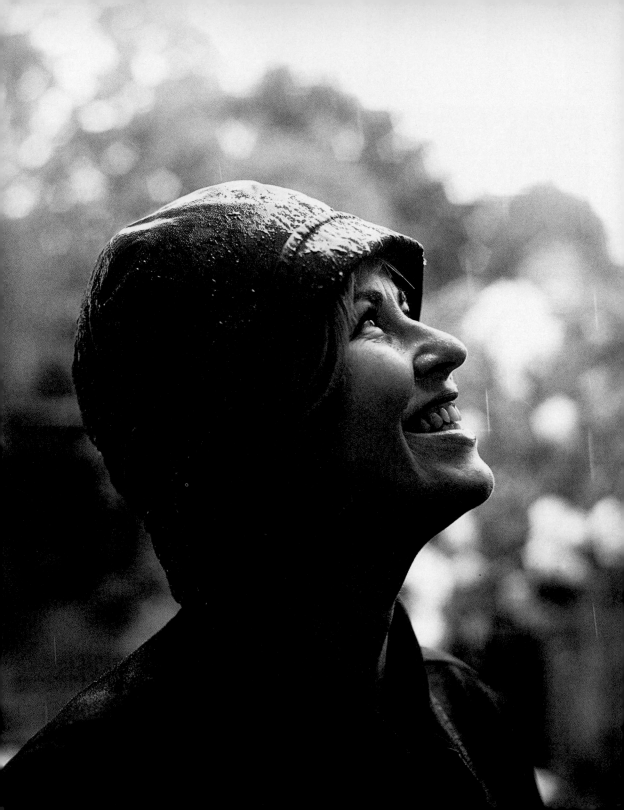

Liza Tarbuck

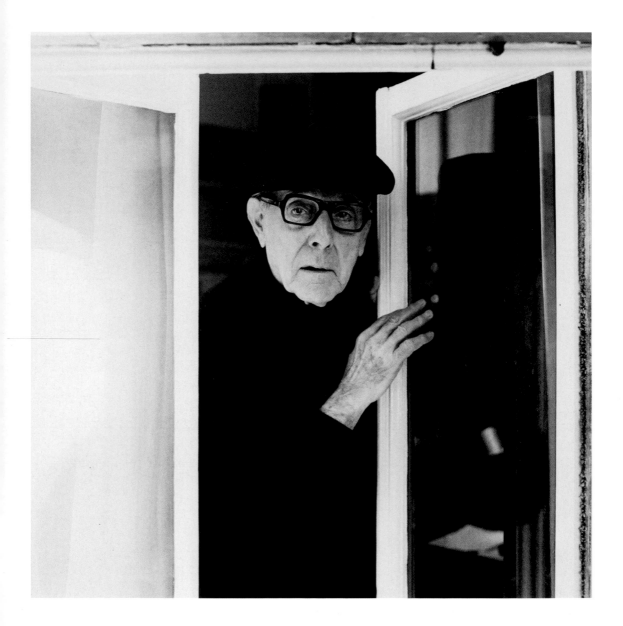

Eric Sykes

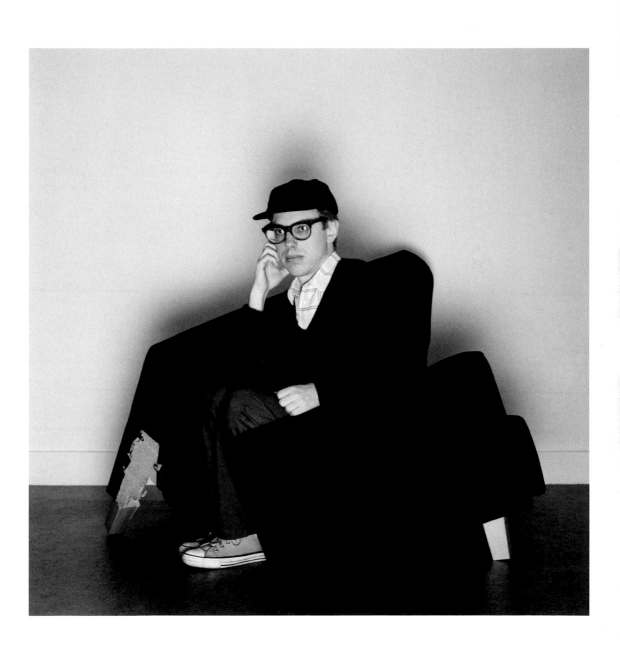

Todd Solondz

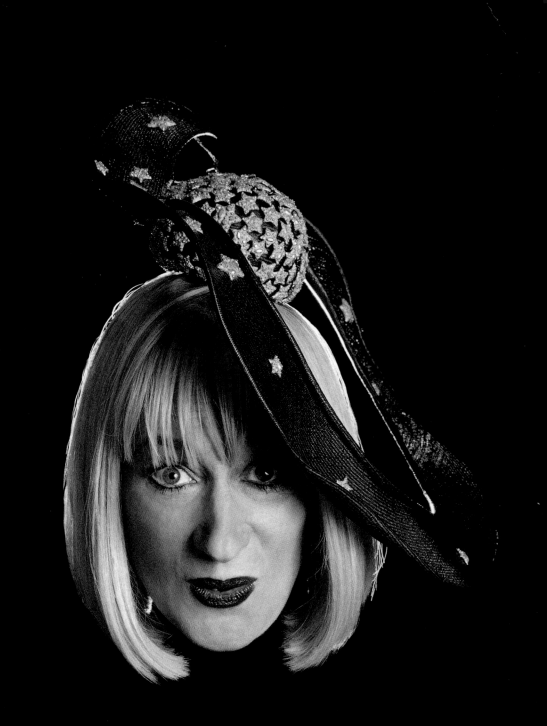

Hattie Hayridge

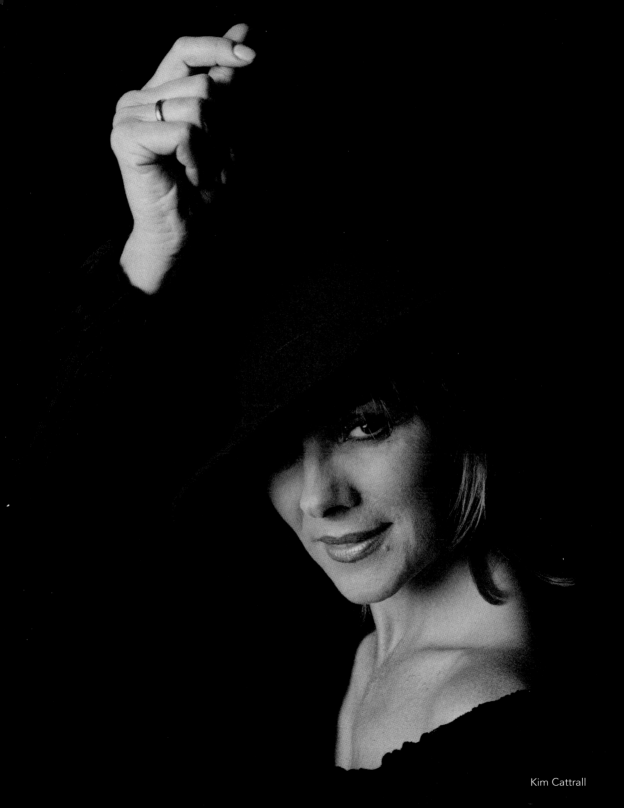
Kim Cattrall

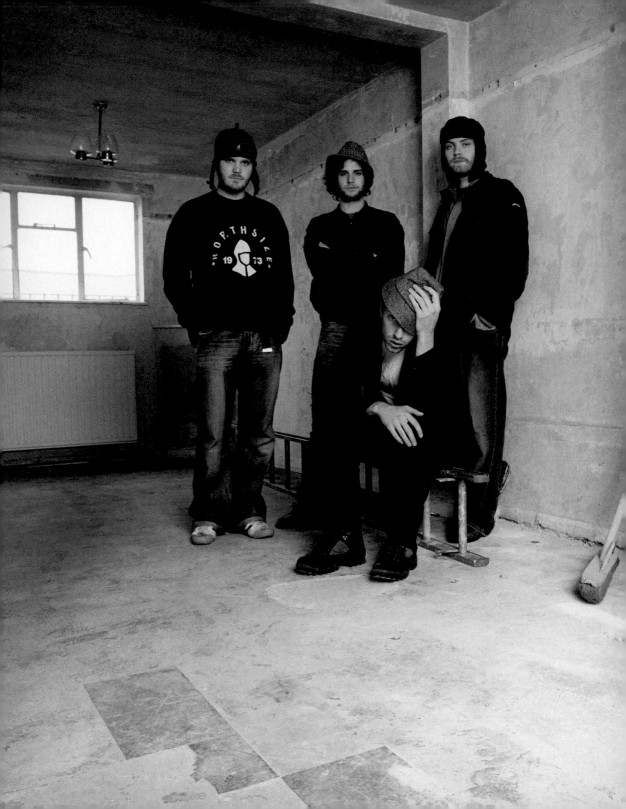

Coldplay

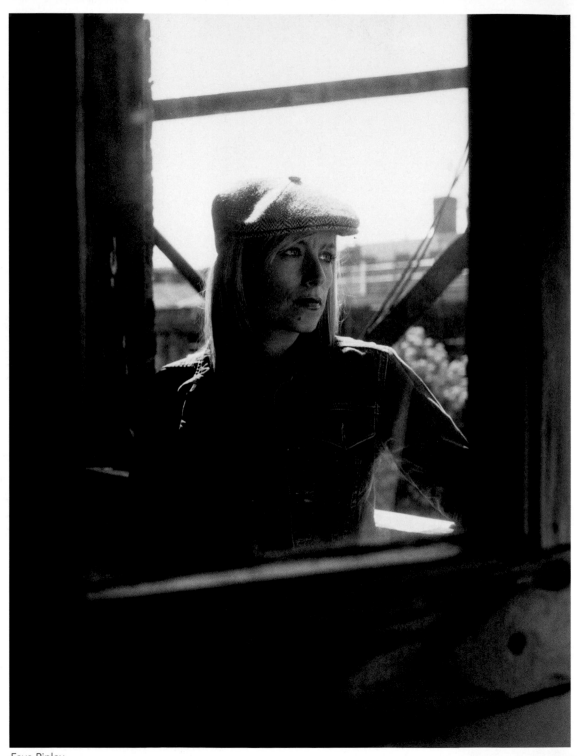

Faye Ripley

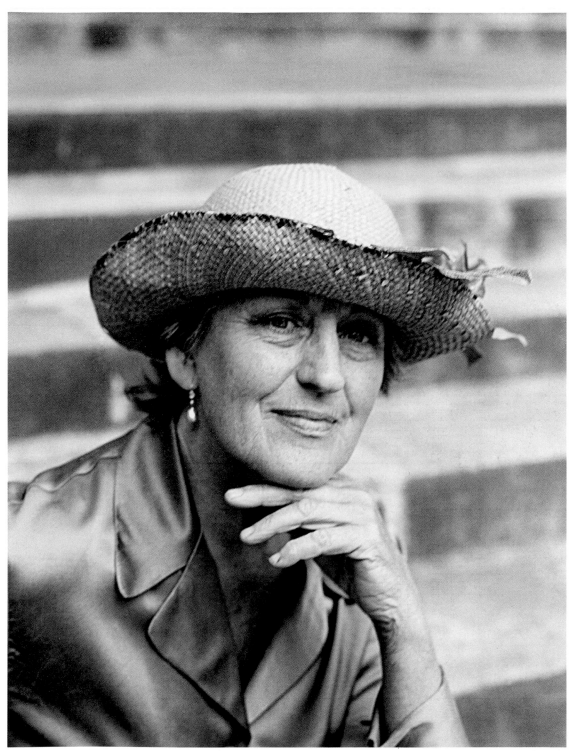

Germaine Greer

James Purefoy

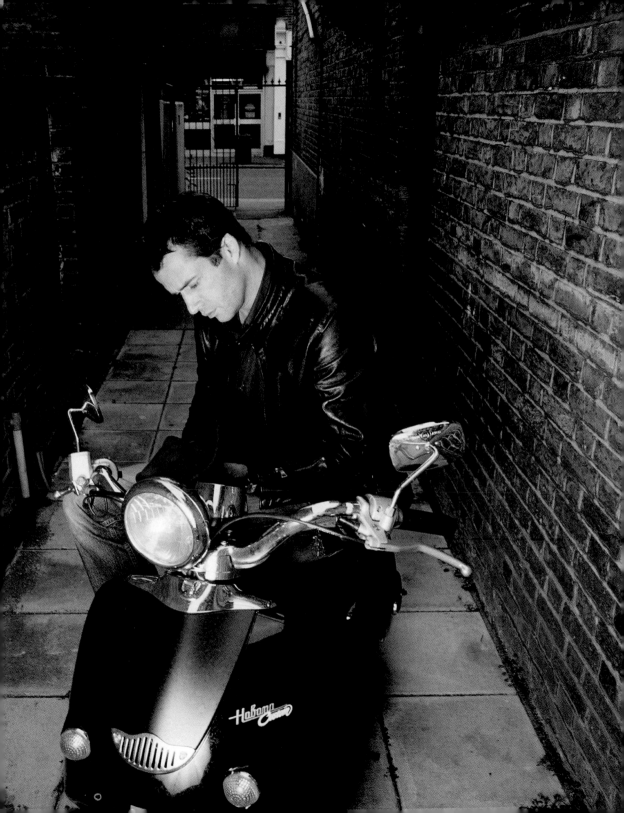

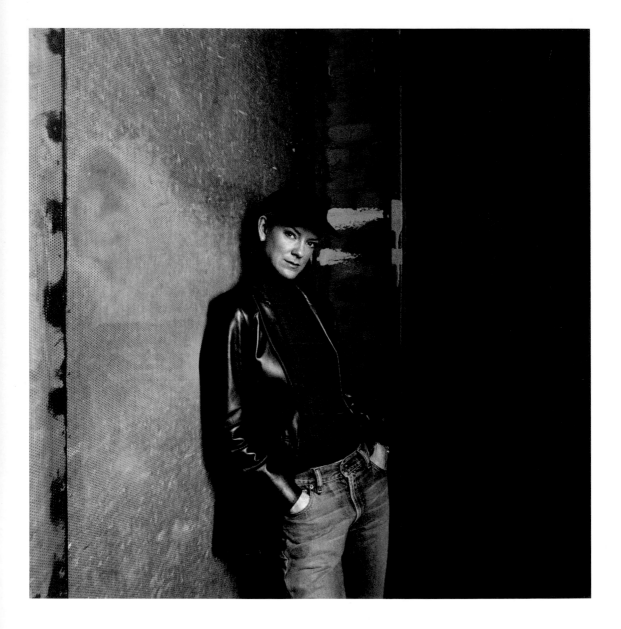

Hermione Norris

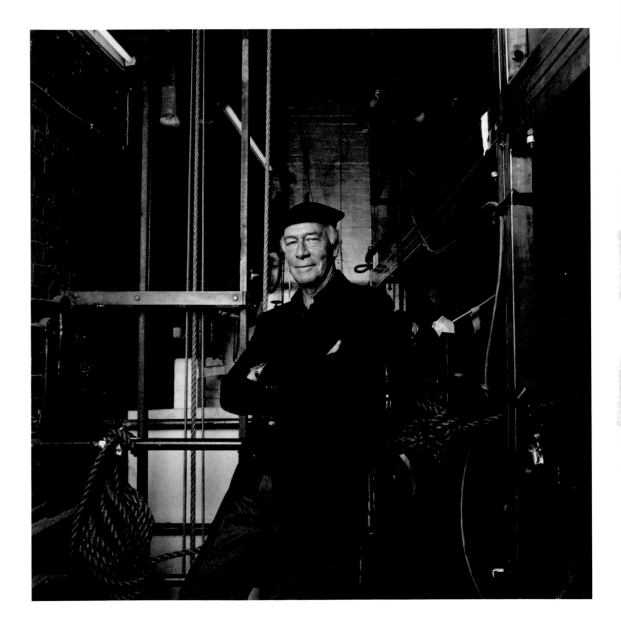

Christopher Plummer

Linus Roache

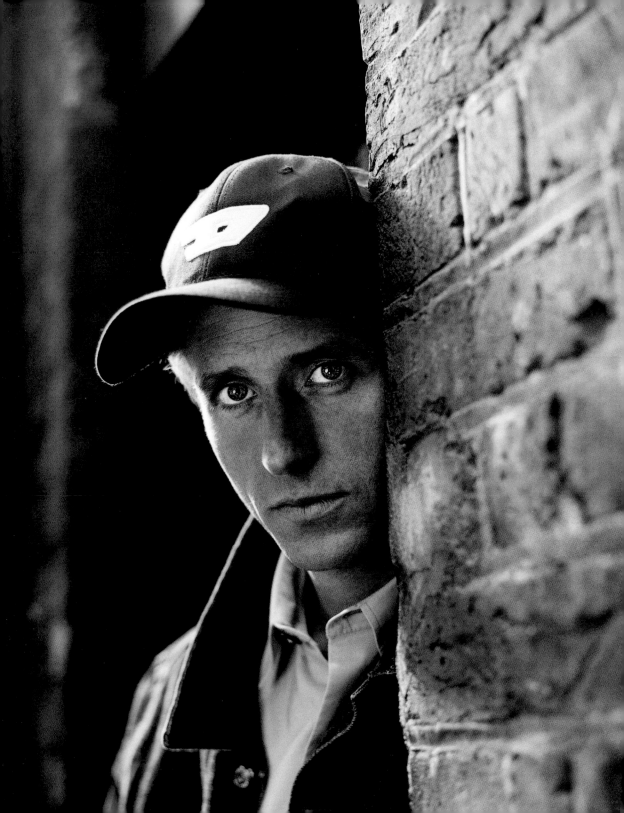

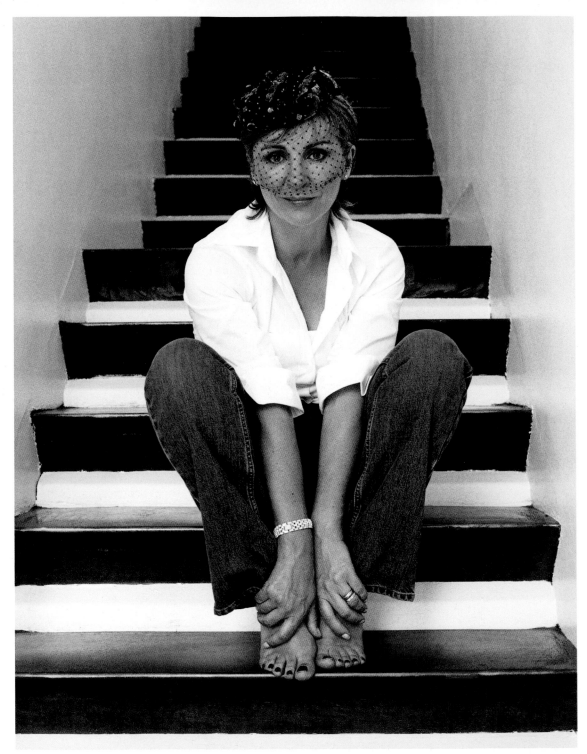

Lesley Garrett

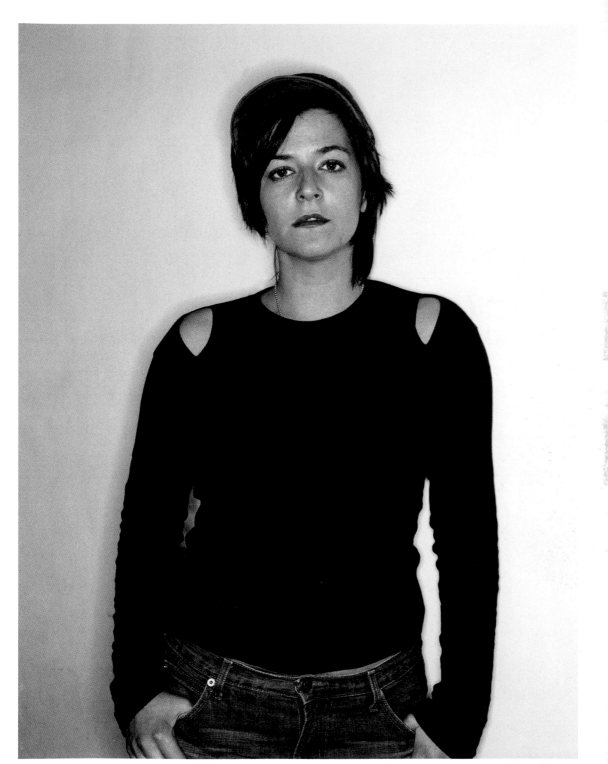

Lynne Ramsay

John Rocha

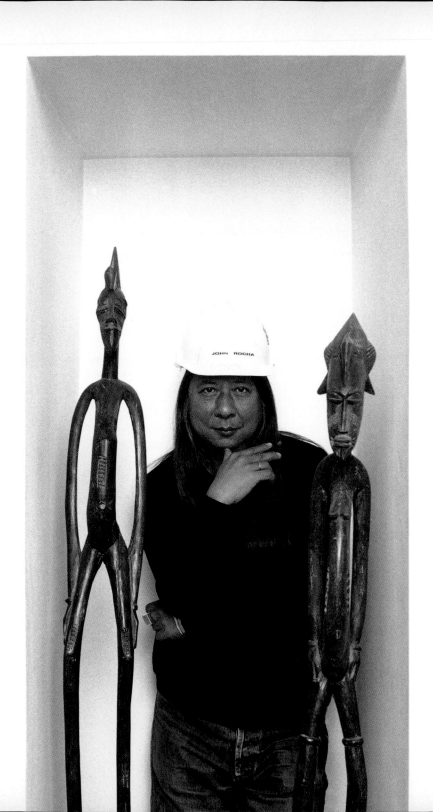

The Corrs

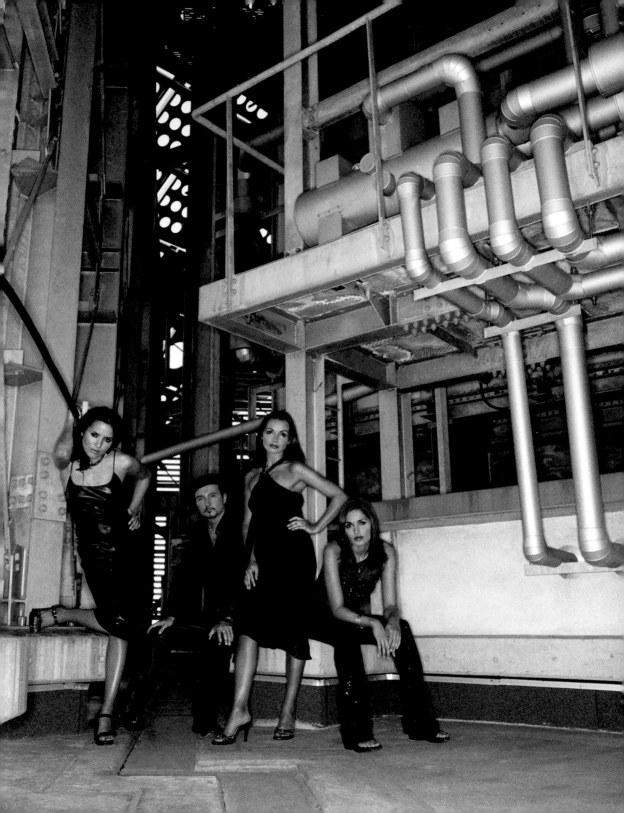

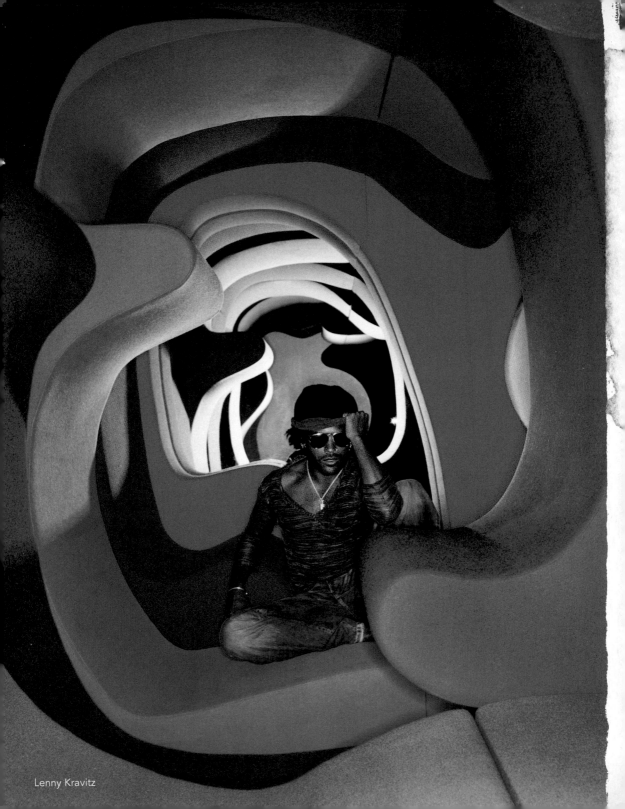

Lenny Kravitz